Harriet Tubman and Sojourner Truth Paper Dolls

Paper doll set includes:

- Instructions
- One Harriet Tubman Paper Doll and one Sojourner Truth Paper Doll
- Short biographies of Harriet Tubman and Sojourner Truth
- Six dresses each for the Harriet Tubman and Sojourner Truth Paper Dolls, which are based on clothes they wore in their photographs
- Attached stand for each paper doll
- Envelope to store your paper dolls and their clothes

Artwork and Sojourner Truth biography by Nova Edwards, Harriet Tubman biography by Dr. Pamela Poulin
Harriet Tubman Paper Doll: ©2010-2017 LVK Paper Dolls, Nova M. Edwards
Sojourner Truth Paper Doll: ©2013, 2017 LVK Paper Dolls, Nova M. Edwards

2nd Edition. All Rights Reserved. The contents of this book, paper doll and clothes, may not be reproduced in whole or in part without written permission.
Email: lvkpaperdolls@aol.com
www.lvkpaperdolls.etsy.com

INSTRUCTIONS

The following instructions are provided to assist you with the enjoyment of your Harriet Tubman and Sojourner Truth paper dolls:

- You will need the following items:
 - scissors
 - glue or tape
- Cut out your paper dolls and their clothes.
- Once your paper dolls and clothes are cut out, use the tabs on the clothes to secure the dresses to the paper dolls.
- Fold the stand that is attached to the base of the dolls on the dotted lines. Do not detach the dolls from the stand.
- Your paper dolls have an envelope in which you can place them and their clothes. To assemble the envelope, follow the instructions below:

 1. Remove the "Back of Envelope" page from the book by cutting on the heavy dashed line.
 2. Front of the envelope:
 a. Remove the front of the envelope (the page with the paper dolls' picture) from the book by cutting on the long, heavy dashed line
 b. Next, cut on the remaining heavy dashed lines
 c. With the front of the page facing you, fold on the dotted lines away from you (backwards) to create flaps
 d. Place the front of the envelope face down
 3. Take the back of the envelope and place it on top of the front of the envelope
 4. Tape or glue the flaps from the front of the envelope to the back of the envelope
 5. Now you're ready to place your paper dolls and their clothes in the envelope you created!

Please note, if you used glue, **wait until the glue dries** before placing your paper dolls and clothes in the envelope.

Harriet Tubman and Sojourner Truth Paper Dolls
(c) 2010-2017 LVK Paper Dolls, Nova M. Edwards
www.lvkpaperdolls.etsy.com

SHORT BIOGRAPHY OF HARRIET TUBMAN
by Dr. Pamela Poulin

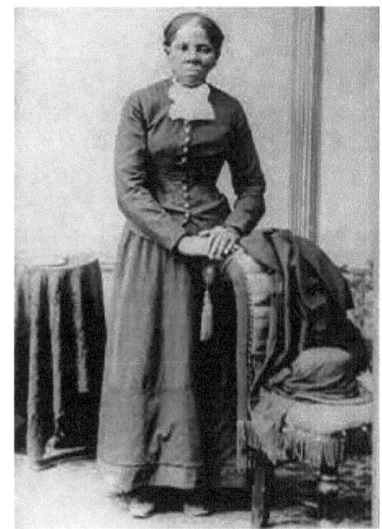

Source: Library of Congress
https://www.loc.gov/rr/program/bib/tubman/

Harriet Tubman (Feb/Mar 1822, Maryland – March 10, 1913, Auburn, NY), also known as (aka) the "Moses of Her People," was born a slave on the Eastern Shore, where she was mistreated (East side of the Chesapeake Bay in Maryland, near Cambridge). After she bravely escaped slavery in 1849, traveling at night through swamps, rivers and forests, following Polaris (the stationary 'North Star' in the Big Dipper, aka the 'Drinking Gourd') and using 'station stops' on the Underground Railroad (UGRR: a series of safe houses), she became a Conductor in the UGRR, making many dangerous trips to MD to bring her extended family and other slaves all the way to St. Catherines, Ontario, Canada (near Niagara Falls).

In addition to being an abolitionist (anti-slavery) and a suffragist (woman's rights advocate), Harriet Tubman was a Union Civil War scout, spy (very dangerous, as she would be hung if caught) and nurse, a much sought after herbalist and 'root doctor' who cured many diseases, (which white Union doctors could not cure), rampant in Union camps.[1] Catherine Clinton wrote in her biography of Harriet Tubman that "Three out of five Civil War soldiers who died during the war were killed by disease *unrelated to wounds* (emphasis mine)."[2,3]

As Tubman was only twice paid by the Union, she supported herself (and supplied the food and clothing needs of the 'Black Freed People' by doing Union soldiers' laundry, as a cook (making 50 pies per night; her mother, also a fine cook), and by selling her homemade root beer.[4] Unfortunately, Harriet Tubman never received a pension for her spy and scouting work for the Union Army; she did receive a pension for being a nurse (however, only $8 per month), risking her life on the battlefield and also saving the lives of many soldiers there and in Camp, with her herbal/root medicines.[5] (There were male nurses as well, such as the American poet Walt Whitman who worked in a hospital in Washington, D.C.)

Harriet Tubman guided abolitionist Col. James Montgomery and his 2nd South Carolina Black Regiment up the Combahee River (in the area of Hilton Head, SC) on June 2, 1863. She became the first woman (black or white) to command an armed military raid. This tremendous and courageous effort resulted in the liberation of over 700 frightened slaves, who, through her wonderful singing voice, she gathered on to the Union boats that took them to safety. Many of these slaves almost immediately volunteered to become Union Army soldiers; they and other blacks made great contributions to the Civil War.

After the Civil War, Harriet Tubman helped 'Black Freed People' find food, and extended family, setting up the (free to poor blacks) John Brown Infirmary, farming vegetables and farm animals, taking into her home poor and ill former slaves (for free) in Auburn, NY, and speaking in favor of civil rights for both black and white women at womens' rights conventions throughout the Northeastern US.

**Here is a woman who truly devoted her entire life –
often at great risk to her own life – to helping others!**

[1] Kate Clifford Larson, Harriet Tubman: Portrait of an American Hero (2004), pp. 224 & 368.
[2] Catherine Clinton, Harriet Tubman: The Road to Freedom (2004), p. 244, endnote 47, as reported by Paul D. Steiner, in his Disease in the Civil War: Natural Biological Warfare in 1861 – 1865 (1968), p. 78.
[3] Clifford Larson, Harriet Tubman, p. 205
[4] Clifford Larson, Harriet Tubman, p. 279. Nurses were not allowed to receive pensions until 1892, some 27 years after the end of the Civil War. Harriet Tubman waited 34 years for her paltry pension of $8, much less than what white nurses received.
[5] NYS Census of Agriculture, 1875.

Harriet Tubman and Sojourner Truth Paper Dolls
(c) 2010-2017 LVK Paper Dolls, Nova M. Edwards
www.lvkpaperdolls.etsy.com

Do visit: Tour the • Harriet Tubman Home in Auburn, NY, where she lived the last 50 years of her life; • St. Catherines near Niagara Falls, Canada, which she and her family called home for ca. eight years (driving and walking tours available); • see also the fine, imaginative exhibits and film at the Harriet Tubman Museum in Cambridge, MD, a few miles from where she was born (driving tours by certified guides are also available).

For pictures and fine biographical information for all ages, see: Kem Knapp Sawyer's, A Photographic Story of a Life, Harriet Tubman (2010), DK Publishing, and Thomas B. Allen's Harriet Tubman, Secret Agent, with artistic, detailed illustrations by Carla Bauer, published by the National Geographic. Also, see the well-written Wikipedia article, which also includes pictures: http://en.wikipedia.org/wiki/Harriet_Tubman.

Pamela L. Poulin, Ph.D., is Professor Emerita, Peabody Conservatory of Music of the Johns Hopkins University. Dr. Poulin also is a soprano soloist, first person portrayer/reenactor and historian of suffragists-abolitionists Matilda Joslyn Gage (Fayetteville, NY) and Amelia Jenks Bloomer (Seneca Falls; 1st woman to own her own newspaper), Mary Young Pickersgill (creator and maker of the "Star Spangled Banner Flag" 1814) and speaker on (as their best friends) Harriet Tubman and Sojourner Truth. Dr. Poulin is an Oxford Press author.

Harriet Tubman and Sojourner Truth Paper Dolls
(c) 2010-2017 LVK Paper Dolls, Nova M. Edwards
www.lvkpaperdolls.etsy.com

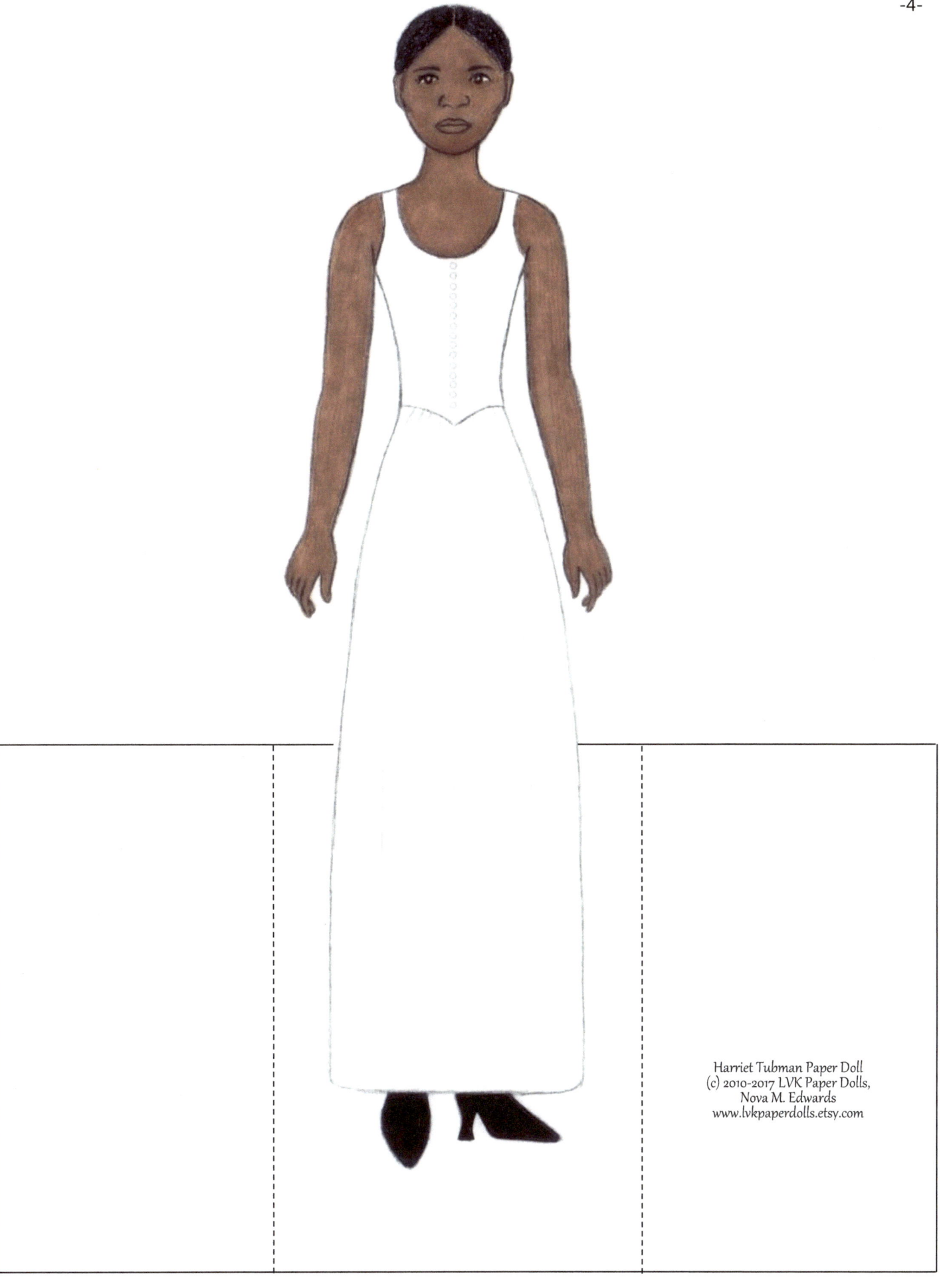

Harriet Tubman Paper Doll
(c) 2010-2017 LVK Paper Dolls,
Nova M. Edwards
www.lvkpaperdolls.etsy.com

Brief Biography of Harriet Tubman (1822—1913)

Harriet Tubman, also known as the "Moses of Her People," was born a slave on the Eastern Shore, MD, where she was mistreated. After she bravely escaped slavery in 1849, using the Underground Railroad (UGRR: a series of safe houses), she became a conductor in the UGRR, making many trips to bring her extended family and other slaves to freedom in Canada.• In addition to being an abolitionist (anti-slavery) and a suffragist (woman's civil rights advocate), Harriet Tubman was a Civil War scout, spy and nurse (a much sought after herbalist who cured many diseases rampant in Union camps). • Guiding Col. James Montgomery and his 2nd South Carolina Black Regiment up the Combahee River (in the area of Hilton Head, SC) on June 2, 1863, she became the first woman to command an armed military raid. This tremendous and courageous effort resulted in the liberation of over 700 slaves, who were freed and gathered on to the Union boats; many volunteered to become Union Army Soldiers. • After the Civil War, Harriet Tubman helped 'Black Freed People' find food, shelter and jobs, and then devoted the rest of her life to taking care of her aging parents and extended family, setting up a free medical clinic, taking into her home in Auburn, NY poor and ill former slaves (who she tended herself), farming vegetables and farm animals to feed all, and speaking at women's rights conventions through the Northeast.

Harriet Tubman truly devoted her entire life to helping others!

Harriet Tubman

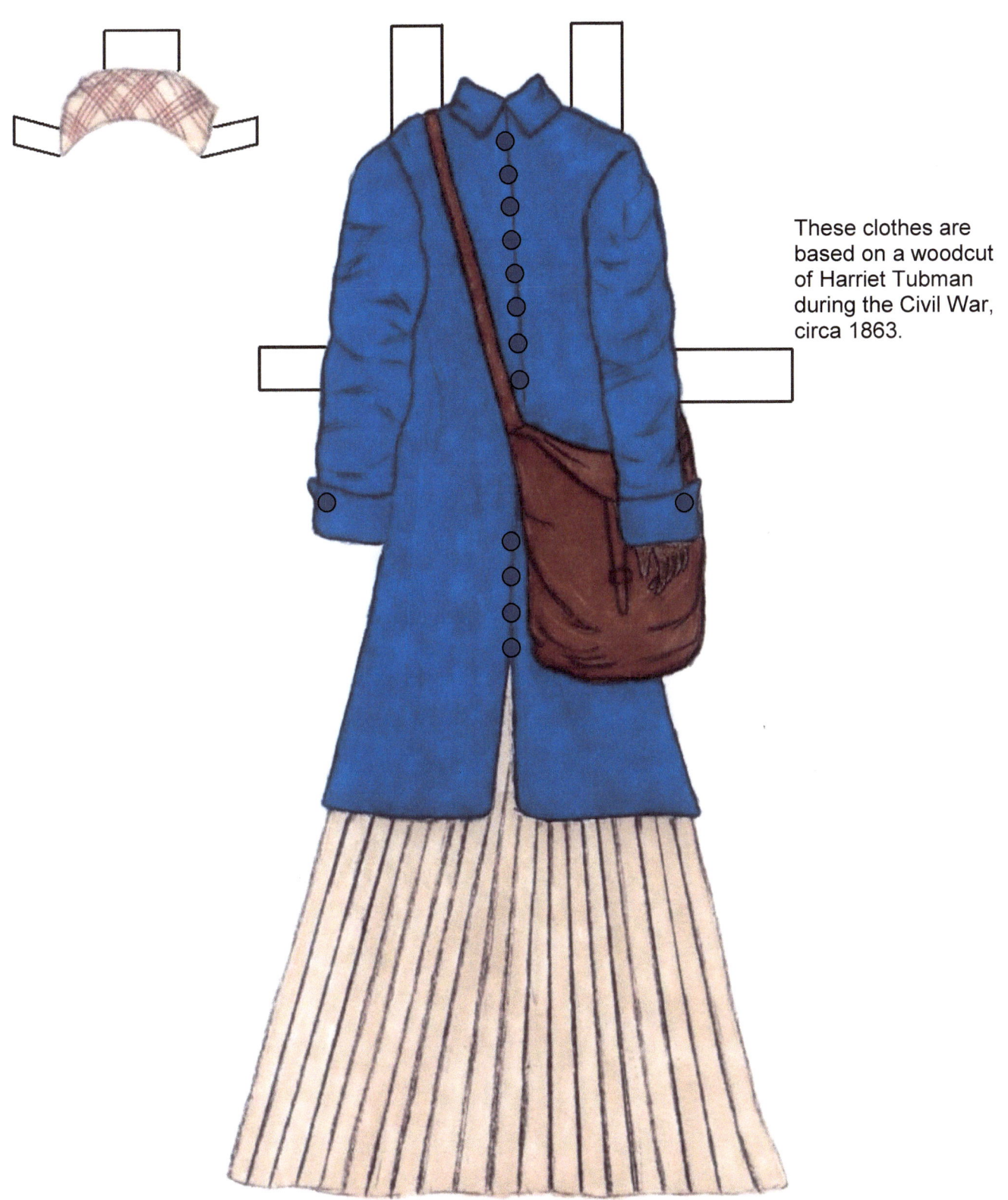

These clothes are based on a woodcut of Harriet Tubman during the Civil War, circa 1863.

Harriet Tubman

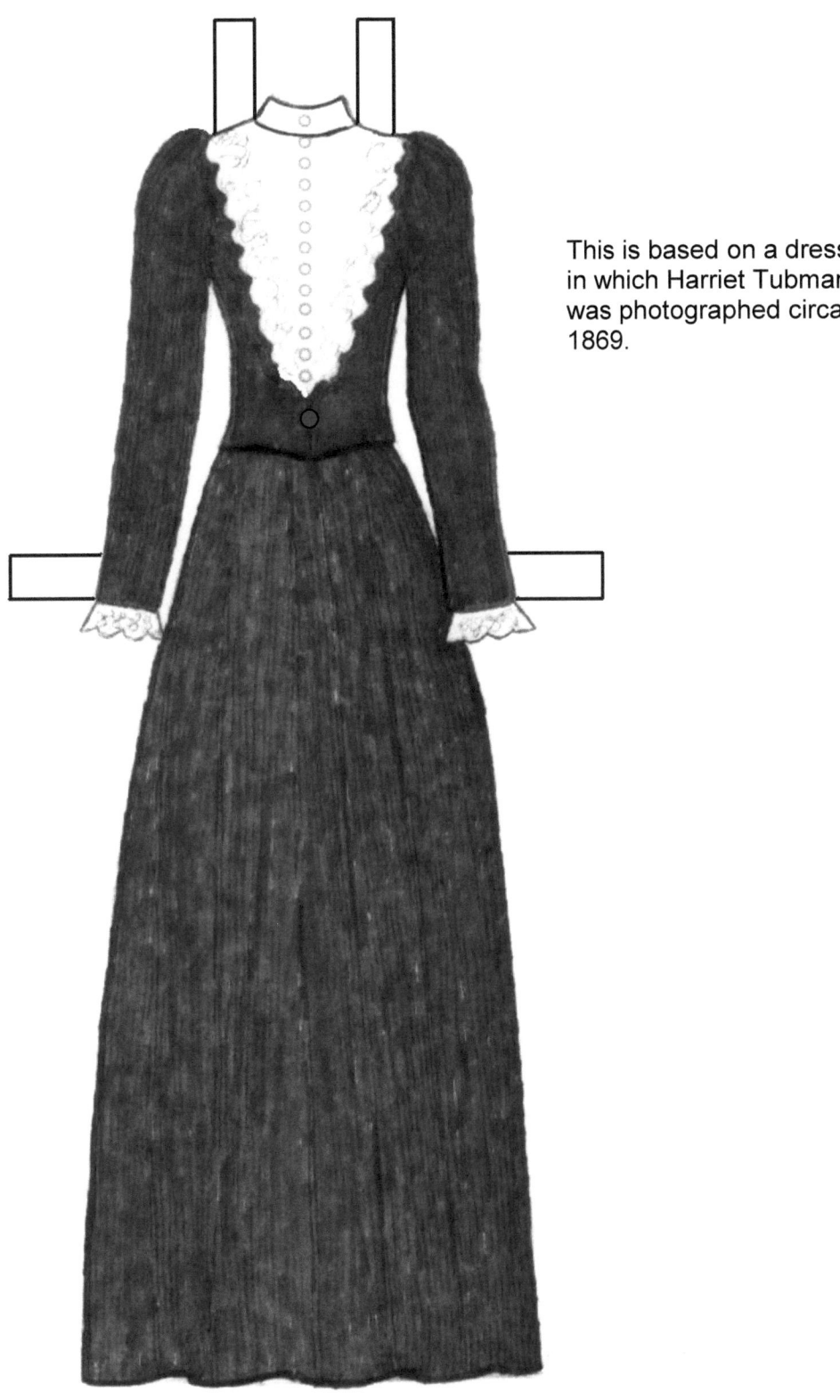

This is based on a dress in which Harriet Tubman was photographed circa 1869.

Harriet Tubman

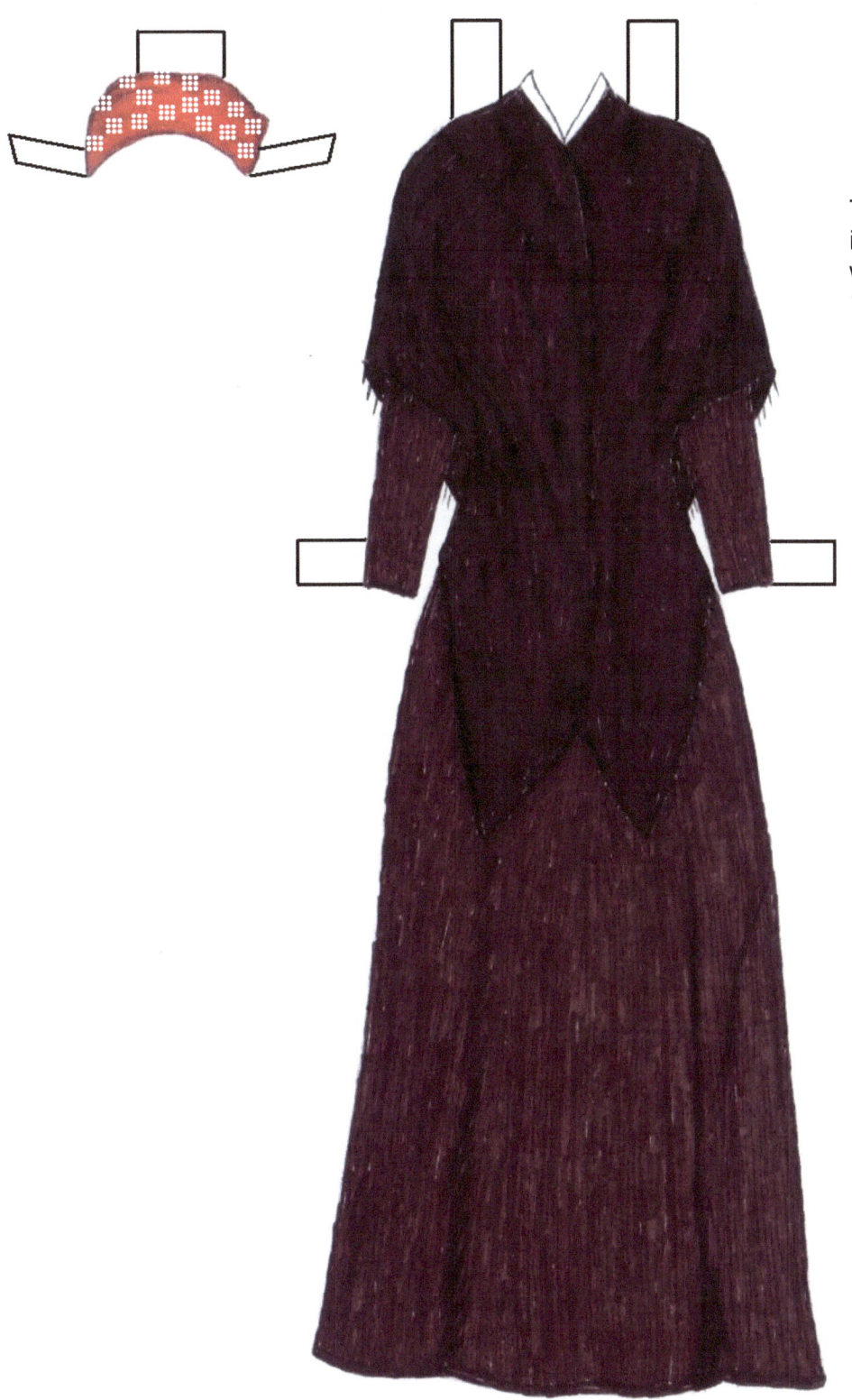

This is based on a dress in which Harriet Tubman was photographed circa 1885.

Harriet Tubman and Sojourner Truth Paper Dolls
(c) 2010-2017 LVK Paper Dolls, Nova M. Edwards
www.lvkpaperdolls.etsy.com

Harriet Tubman

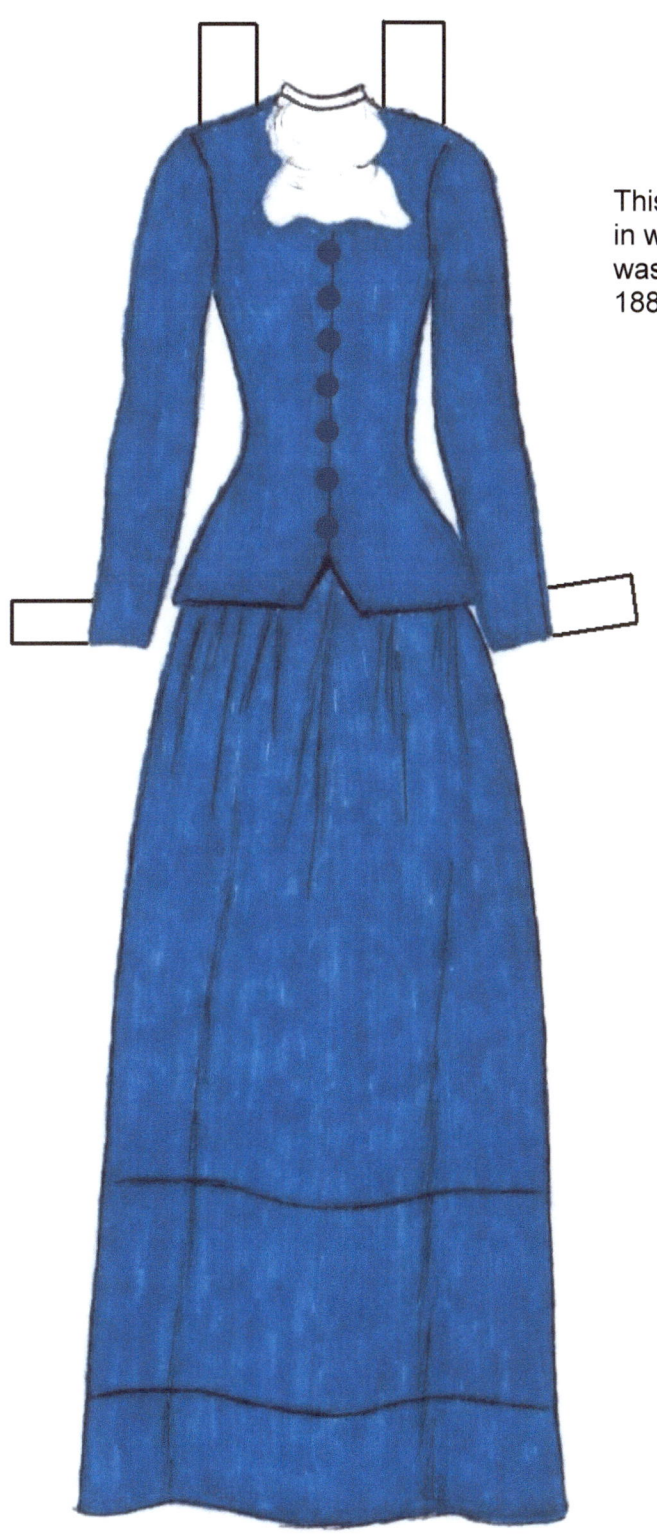

This is based on a dress in which Harriet Tubman was photographed circa 1885.

Harriet Tubman and Sojourner Truth Paper Dolls
(c) 2010-2017 LVK Paper Dolls, Nova M. Edwards
www.lvkpaperdolls.etsy.com

Harriet Tubman

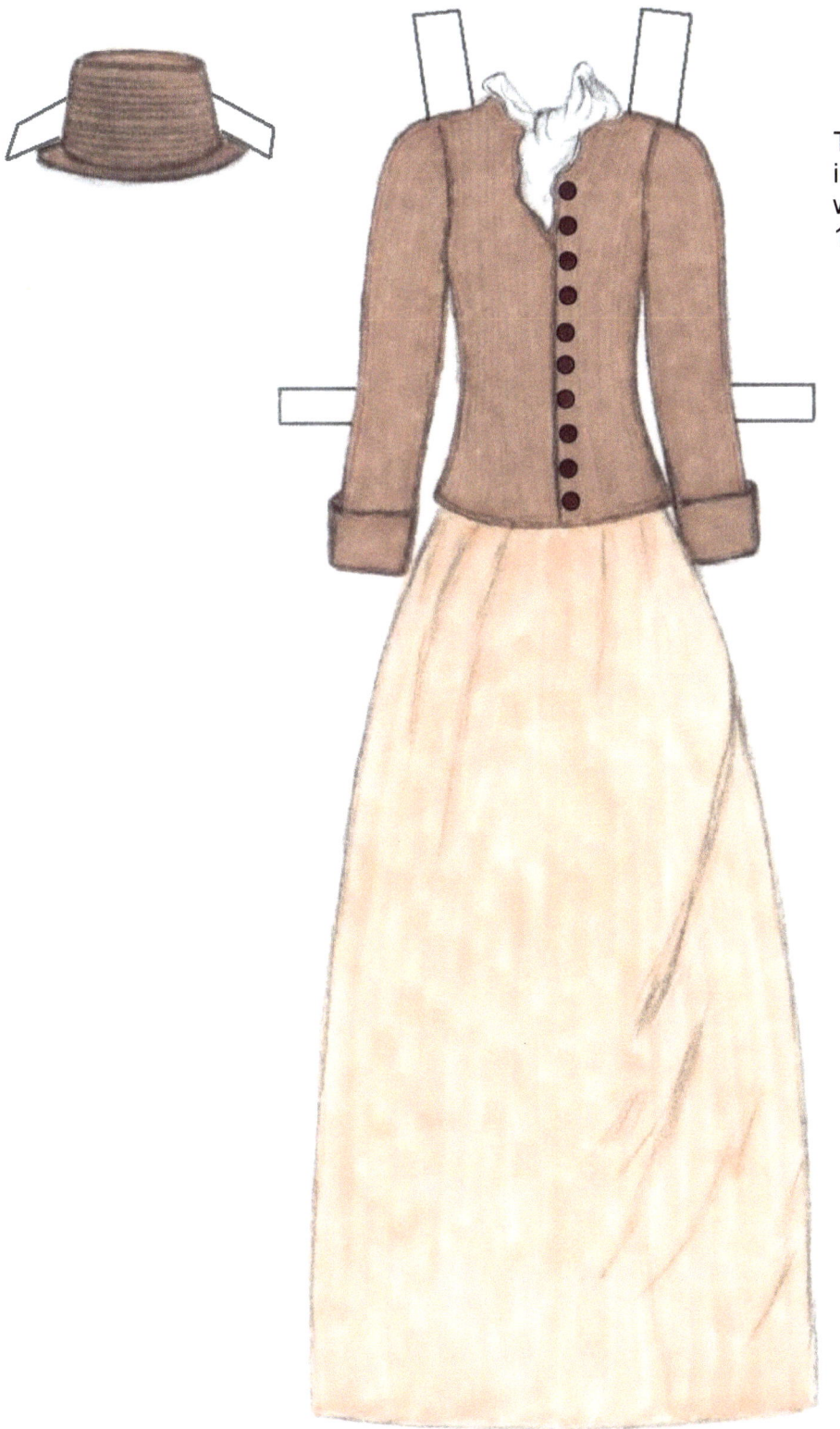

This is based on a dress in which Harriet Tubman was photographed circa 1887.

Harriet Tubman

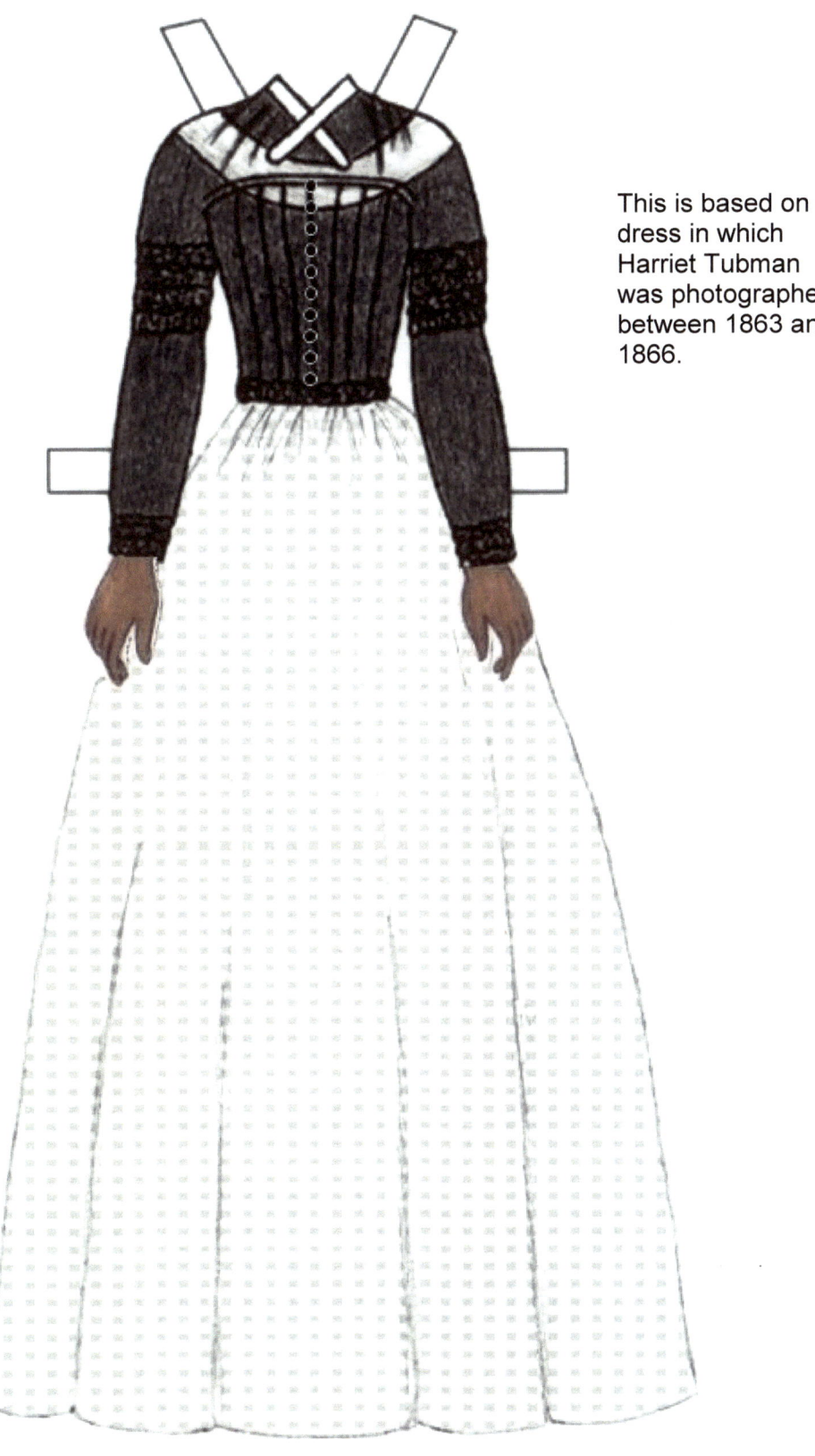

This is based on a dress in which Harriet Tubman was photographed between 1863 and 1866.

Harriet Tubman and Sojourner Truth Paper Dolls
(c) 2010-2017 LVK Paper Dolls, Nova M. Edwards
www.lvkpaperdolls.etsy.com

SHORT BIOGRAPHY OF SOJOURNER TRUTH[1,2]
(c. 1797 – November 26, 1883)

Sojourner Truth was born into slavery between 1797 and 1800, by the name of Isabella; however, in 1843, she gave herself the name Sojourner Truth. Truth was the daughter of James (Bomefree) and Betsey (Mau-mau Bett) who were slaves of Colonel Ardinburgh of Hurley, Ulster County, New York. Truth came from a large family; she had approximately 10-12 siblings. She and her family lived in an area that had once been controlled by the Dutch. Therefore, Truth and her family spoke fluent Dutch.

When Truth was nine years old, Colonel Ardinburgh died and his son inherited ownership of Truth and her family. Sadly, Truth was separated from her family and sold for $100 with a flock sheep to John Nealy. However, since Bomefree was older and poor health, the heirs of Colonel Ardinburgh made a financial decision that it would be better to give Mau-mau Bett her freedom so that the burden to care for Bomefree would be hers instead of Ardinburgh's heirs.

In 1810, Truth was sold to John J. Dumont, who once promised her freedom. Around 1827, after Dumont reneged on his promise, Truth escaped slavery with her infant daughter. When Dumont found her, she refused to return with him. Mr. Isaac Van Wagenen interceded and offered to buy her services from Dumont for $20 and he gave Dumont $5 for the infant. Soon afterwards Truth discovered that her five year-old son Peter was illegally sold to a man in Alabama. Truth rescued her son from the South by successfully winning a case against the white man who bought him illegally. She was the first black woman to successfully challenge a white man in a United States court.

In 1844, she joined the Northampton Association of Education and Industry in Northampton, Massachusetts, an organization founded by abolitionists. It was in this organization that she met Frederick Douglas and other influential abolitionists. Although the organization ended in 1846, Truth continued her career as an activist, and she went on tour to participate in speaking engagements.

During the Civil War, Truth helped to recruit black troops for the Union Army. Her grandson James Caldwell enlisted in the 54th Massachusetts Regiment at her encouragement. In 1864, Truth went to Washington, D.C. to contribute to the National Freedman's Relief Association. During that time, she had the opportunity to speak President Abraham Lincoln about her beliefs and her experience.

Truth was an extraordinary civil rights advocate who fought for prison reform, the abolishment of slavery, and suffrage.

To learn more about Sojourner Truth, visit these websites and museums below:

- http://www.press.uillinois.edu/books/catalog/48abk7zm9780252034190.html. Book: "Sojourner Truth's America," by Margaret Washington, professor of history and American studies at Cornell University,
- http://sojournertruthmemorial.org/sojourner-truth/her-words/
- https://www.nps.gov/wori/learn/historyculture/sojourner-truth.htm
- http://www.sojoartsmuseum.org/

Source: The UC Berkeley Art Museum and Pacific Film Archive is the visual arts center of the University of California, Berkeley (BAMPFA)
http://www.bampfa.berkeley.edu/program/sojourner-truth-photography-and-fight-against-slavery

[1] "A Celebration of Women Writers, The Narrative of Sojourner Truth," Dictated by Sojourner Truth (ca.1797-1883), edited by Olive Gilbert, 1850. http://digital.library.upenn.edu/women/truth/1850/1850.html. Accessed June 2017.
[2] http://www.biography.com/people/sojourner-truth-9511284. Accessed January 2014.

Harriet Tubman and Sojourner Truth Paper Dolls
(c) 2010-2017 LVK Paper Dolls, Nova M. Edwards
www.lvkpaperdolls.etsy.com

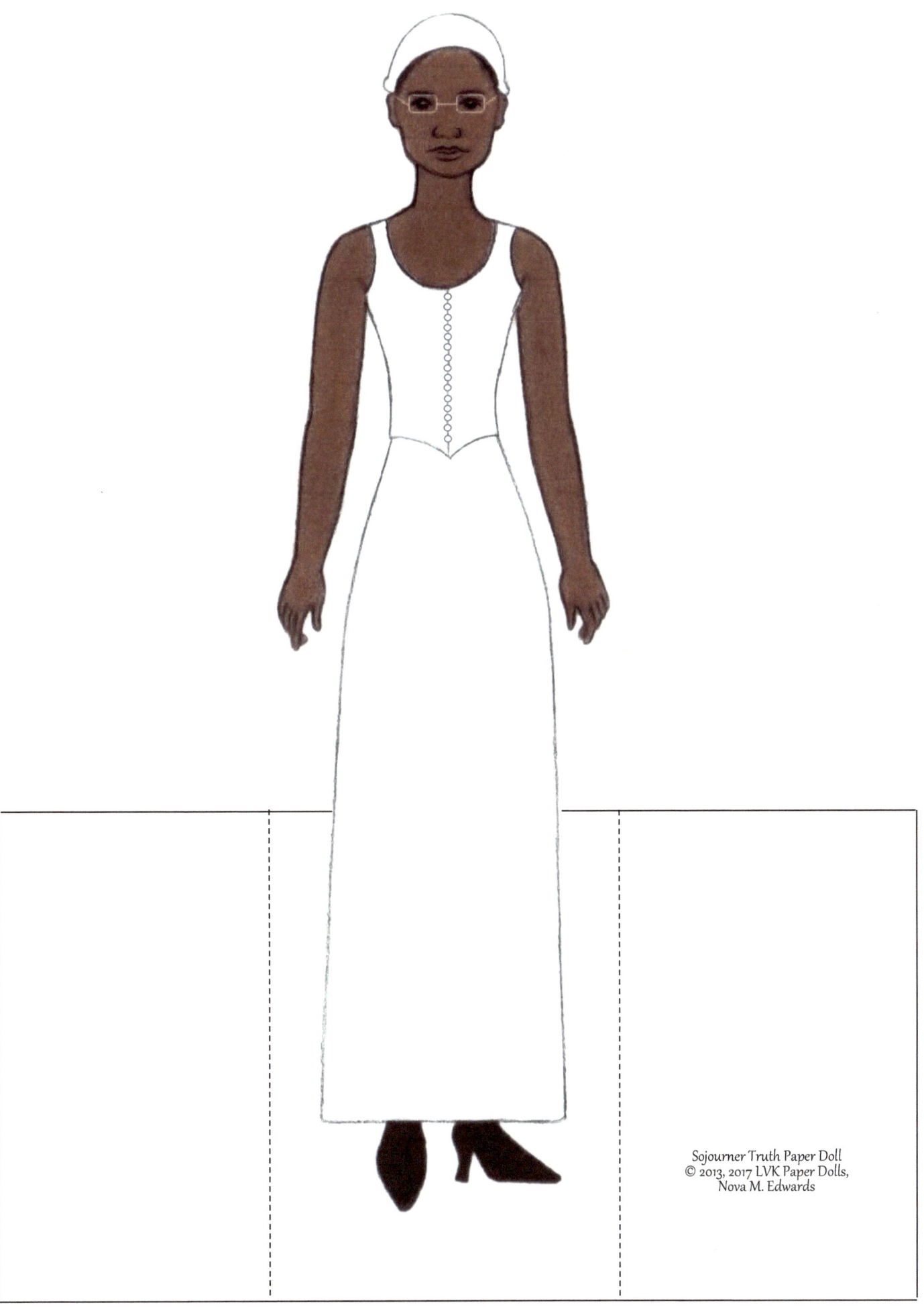

Sojourner Truth Paper Doll
© 2013, 2017 LVK Paper Dolls,
Nova M. Edwards

Brief Biography of Sojourner Truth (c. 1797 – 1883)

Sojourner Truth was born into slavery circa 1797, by the name of Isabella; however, in 1843, she gave herself the name Sojourner Truth. Truth came from a large family. She and her family were owned by Colonel Ardinburgh and they lived in an area that had once been controlled by the Dutch. Therefore, Truth and her family spoke fluent Dutch. When Truth was nine years old, Colonel Ardinburgh died and his son inherited ownership of Truth and her family. Sadly, Truth was separated from her family and was sold with a flock of sheep for $100. Around 1827, Truth escaped slavery with her infant daughter. When she discovered that her five year-old son was illegally sold to a man in Alabama, she rescued him by successfully winning a case against the white man who bought him illegally. During the Civil War, Truth helped to recruit black troops for the Union Army. In 1864, Truth went to Washington, D.C. to contribute to the National Freedman's Relief Association. During that time, she had the opportunity to speak President Abraham Lincoln about her beliefs and her experience. Truth was an extraordinary civil rights advocate who fought for prison reform, the abolishment of slavery, and suffrage.

Sojourner Truth

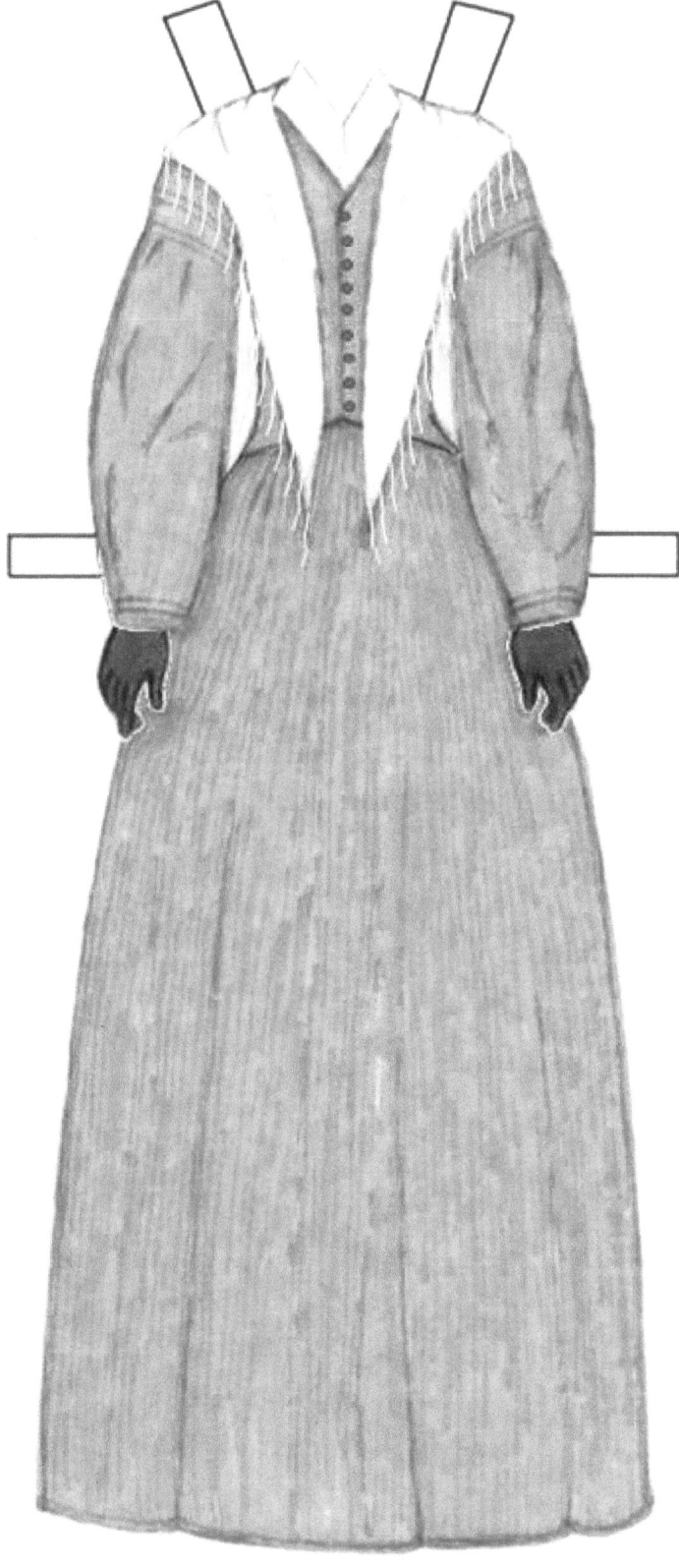

Sojourner Truth usually was photographed wearing shawls. This dress, as the others, are representative of the dresses she wore in her pictures.

Sojourner Truth

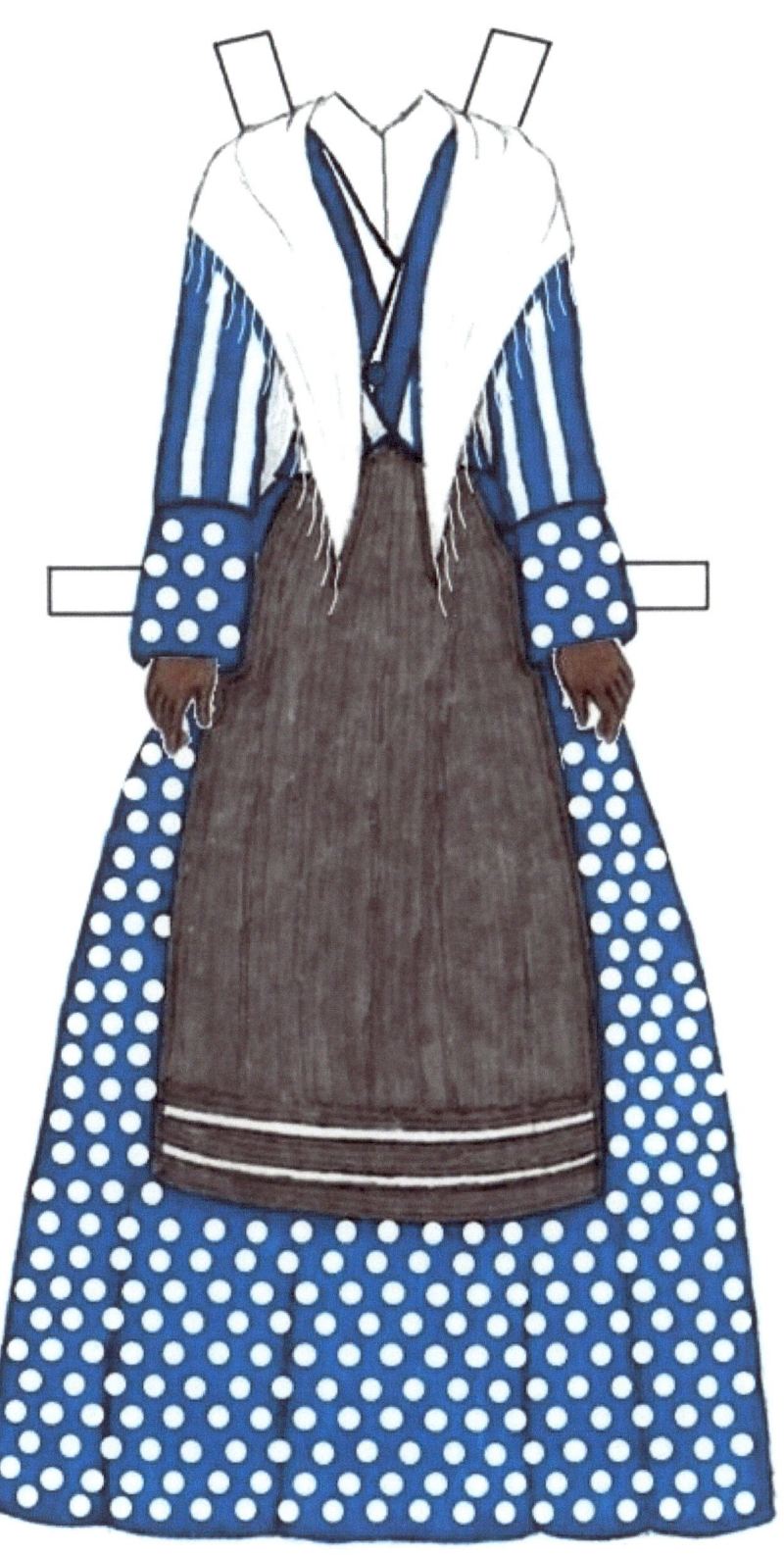

Sojourner Truth

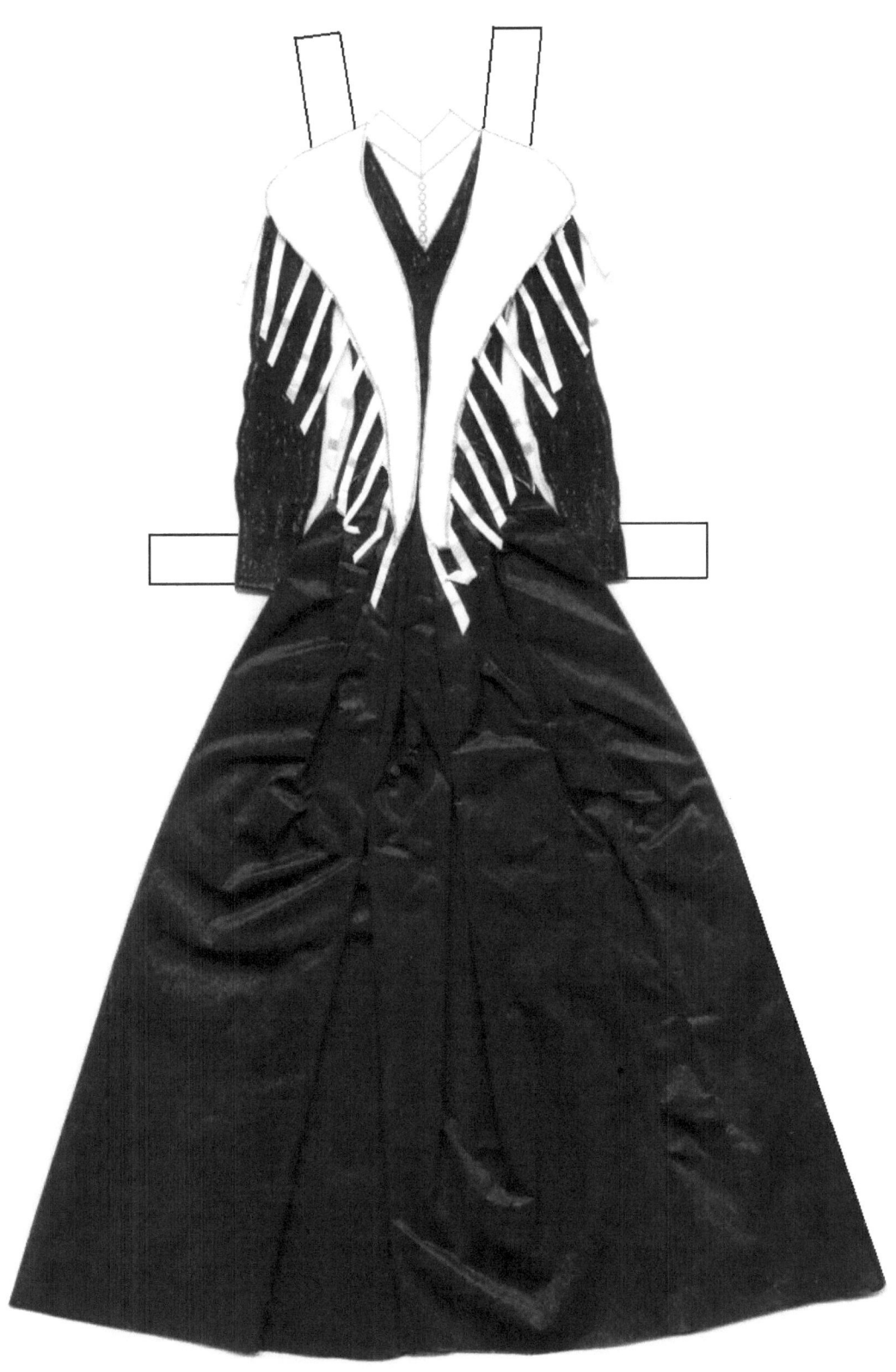

Harriet Tubman and Sojourner Truth Paper Dolls
(c) 2010-2017 LVK Paper Dolls, Nova M. Edwards
www.lvkpaperdolls.etsy.com

Sojourner Truth

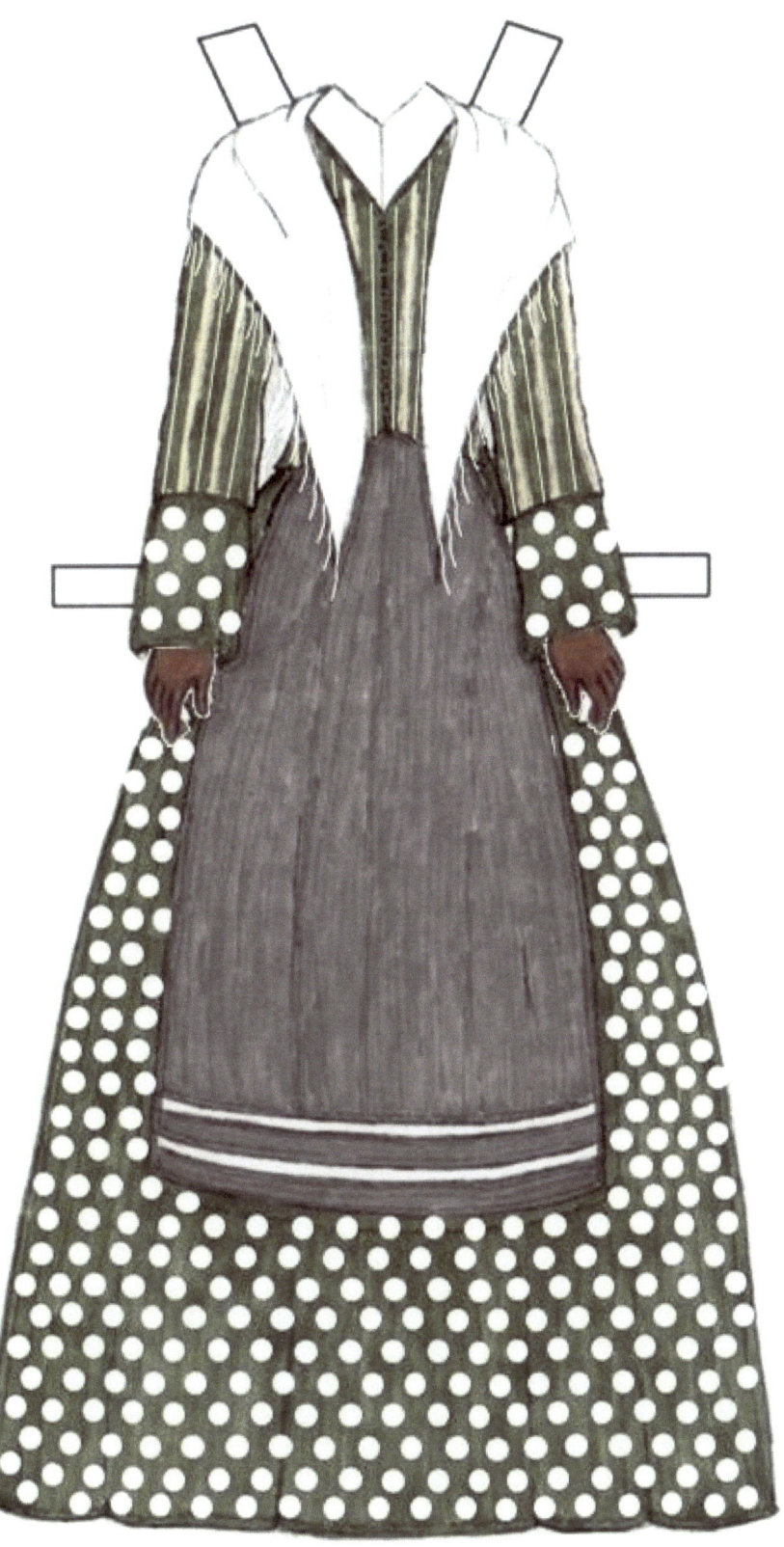

Harriet Tubman and Sojourner Truth Paper Dolls
(c) 2010-2017 LVK Paper Dolls, Nova M. Edwards
www.lvkpaperdolls.etsy.com

Sojourner Truth

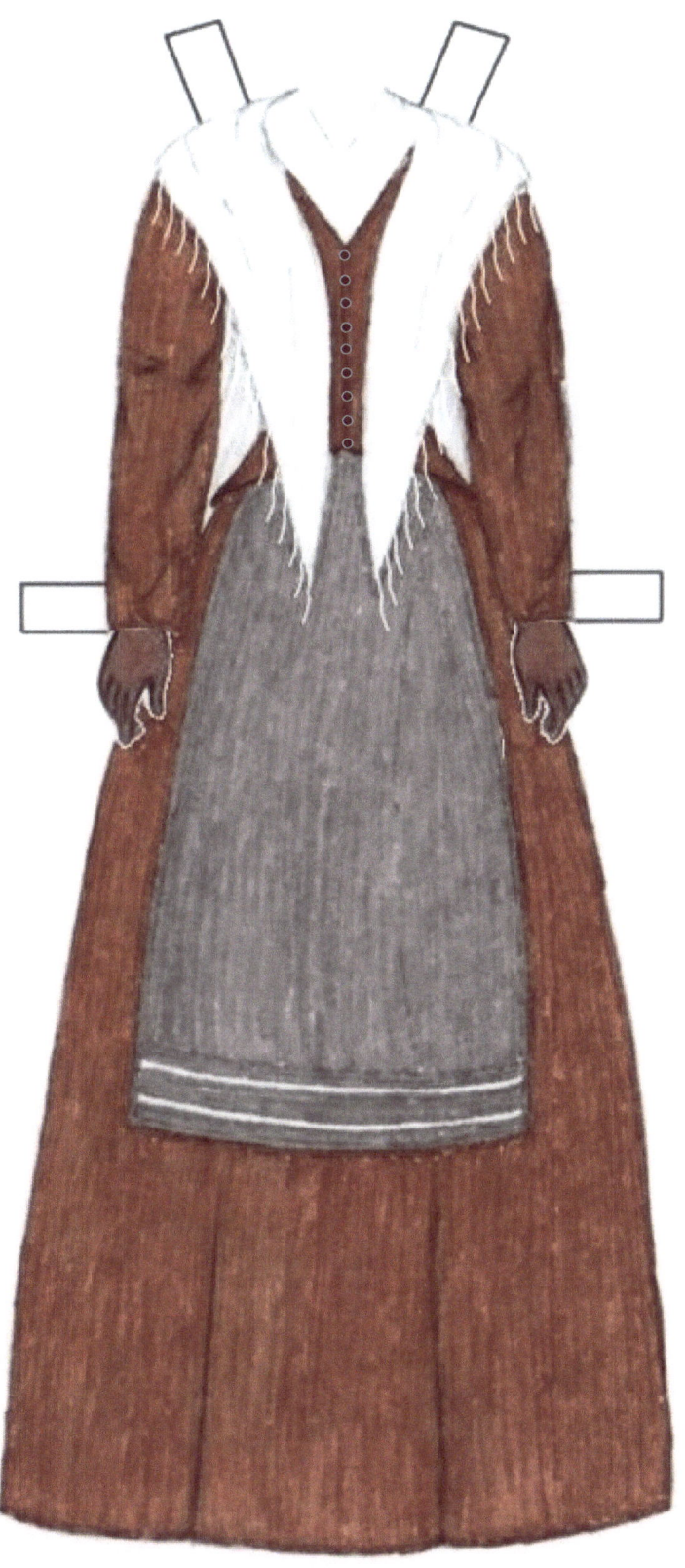

Sojourner Truth

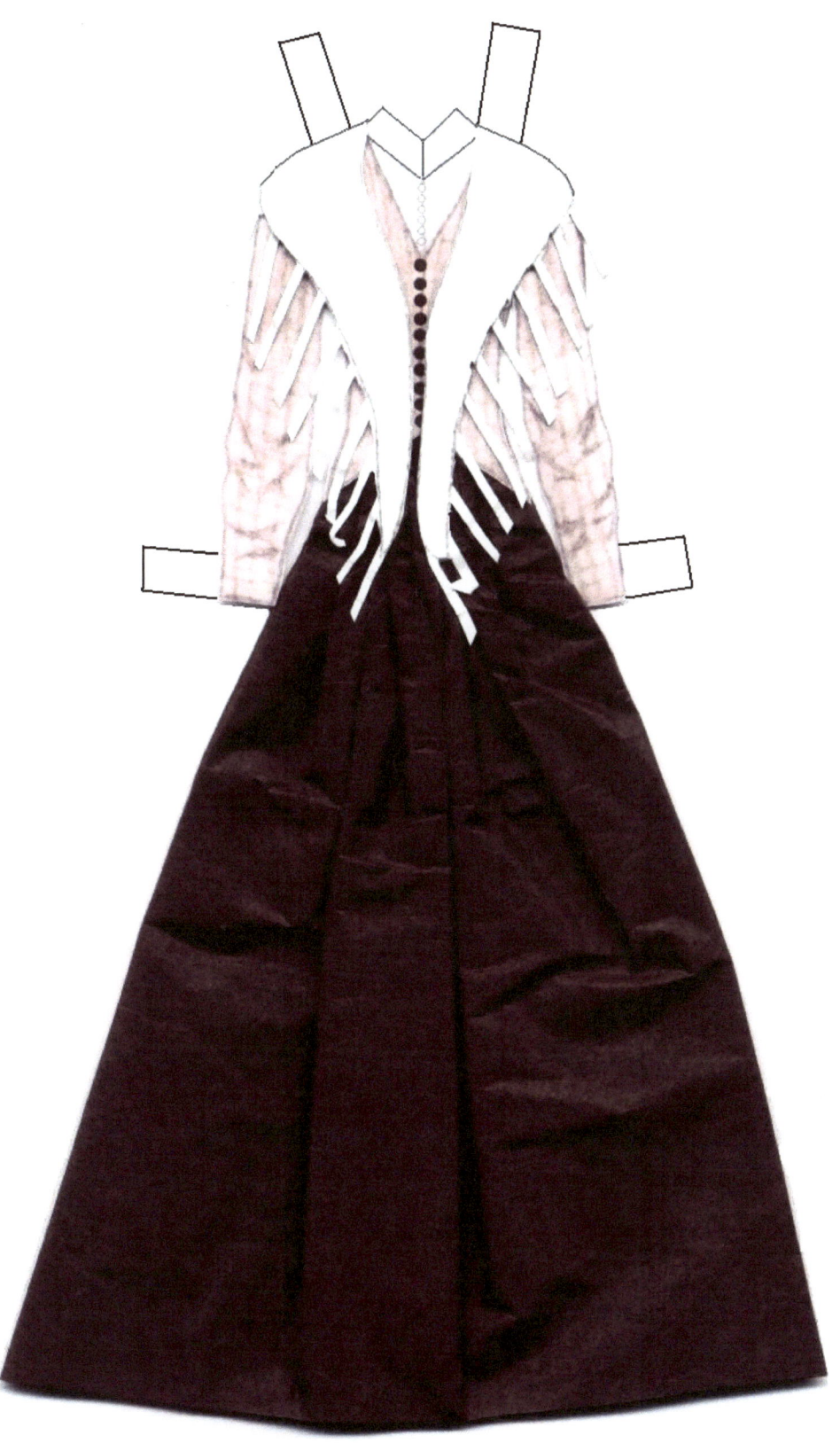

Cut on this line to remove the page.

Back of Envelope

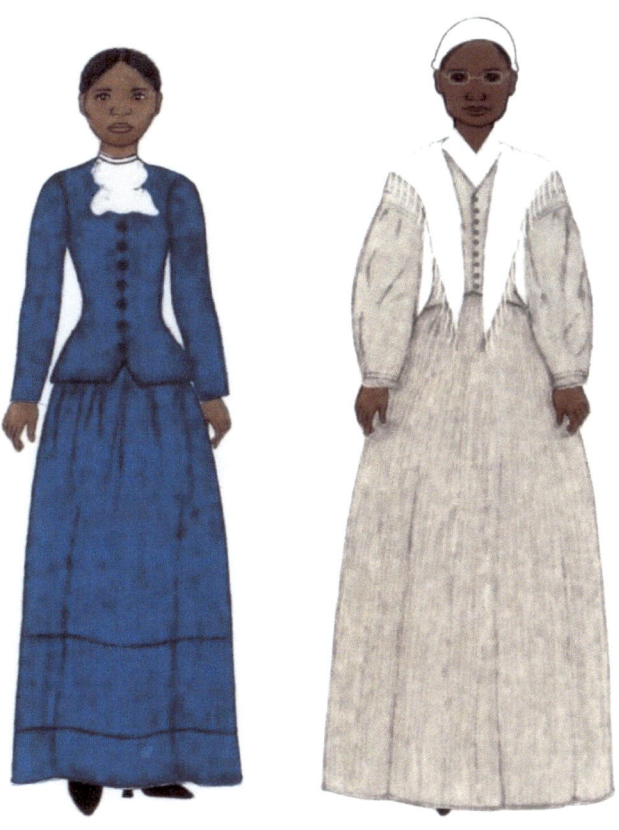

Harriet Tubman and Sojourner Truth Paper Dolls and Clothes Envelope

(c) 2010-2017 LVK Paper Dolls, Nova M. Edwards

www.ingramcontent.com/pod-product-compliance
Lightning Source LLC
Chambersburg PA
CBHW051111180526
45172CB00002B/866